Ornamental Animals
Coloring Boook for Adults

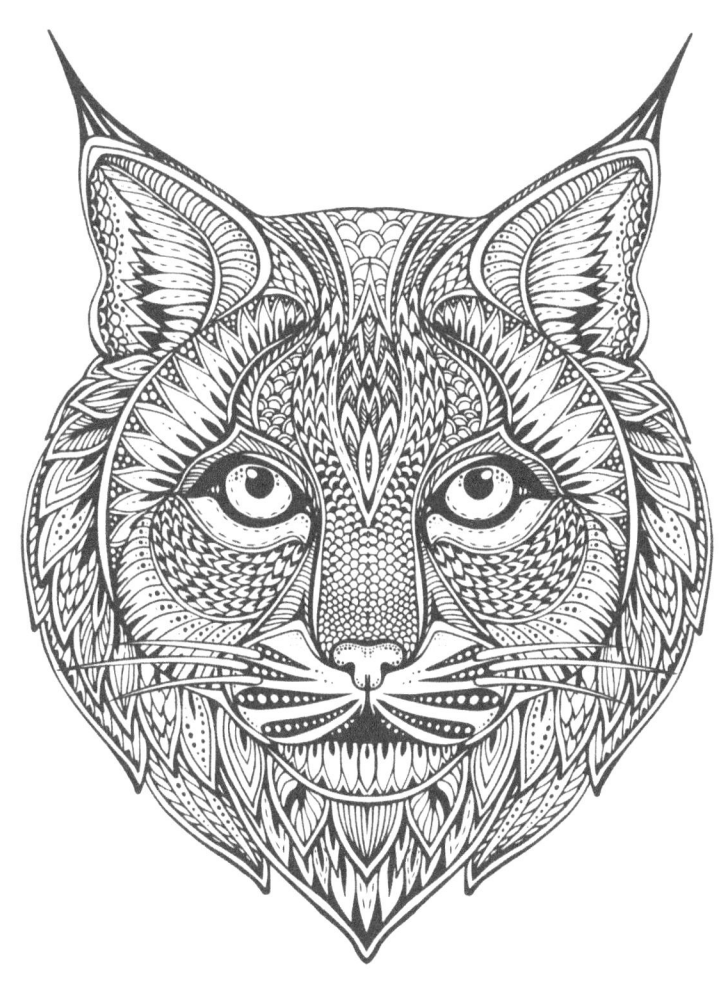

Sophia Payne

Copyright: Published in the United States by Sophia Payne

Published November 2016

All rights reserved. No part of this publication may be reproduced, stored in retrieval system, copied in any form or by any means, electronic, mechanical, photocopying, recording or otherwise transmitted without written permission from the publisher. Please do not participate in or encourage piracy of this material in any way. You must not circulate this book in any format. Sophia Payne does not control or direct users' actions and is not responsible for the information or content shared, harm and/or actions of the book readers.

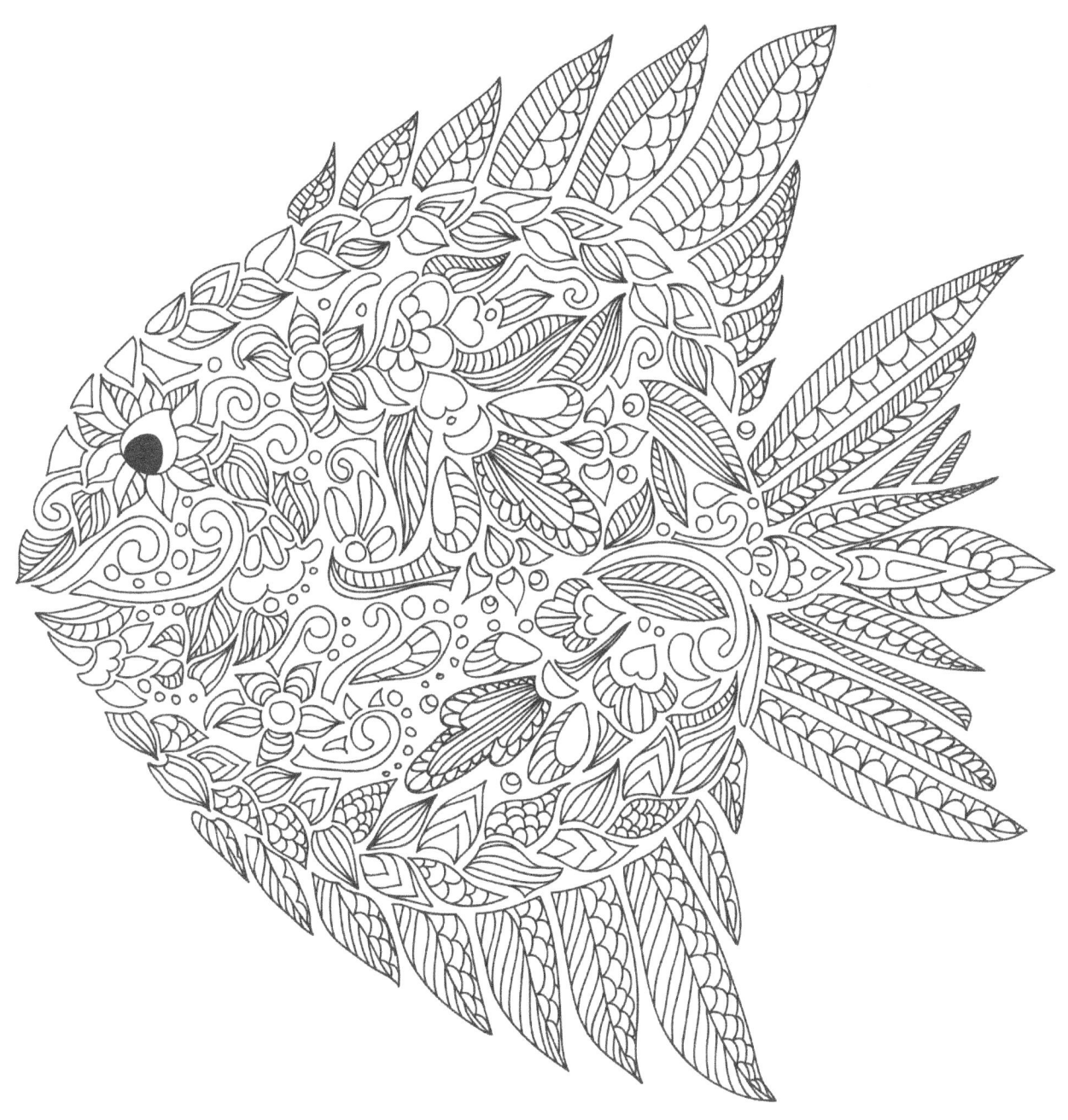

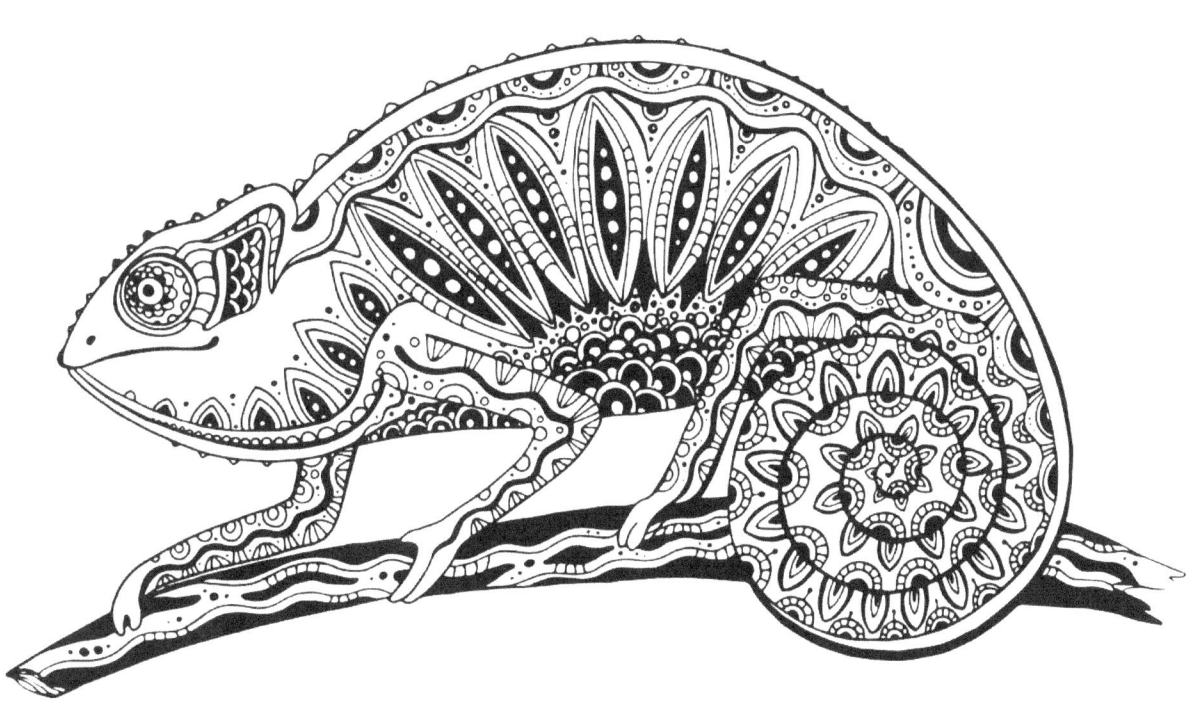

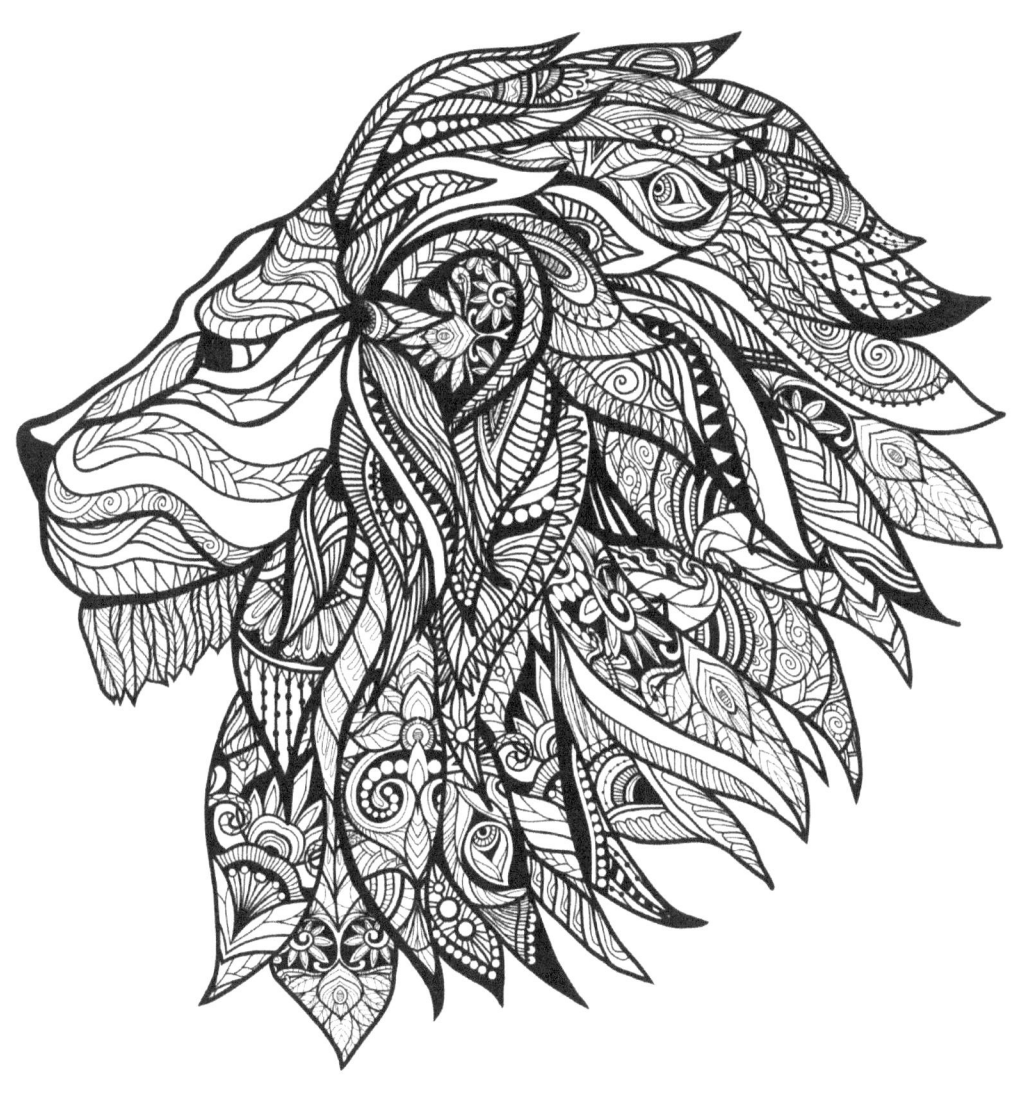

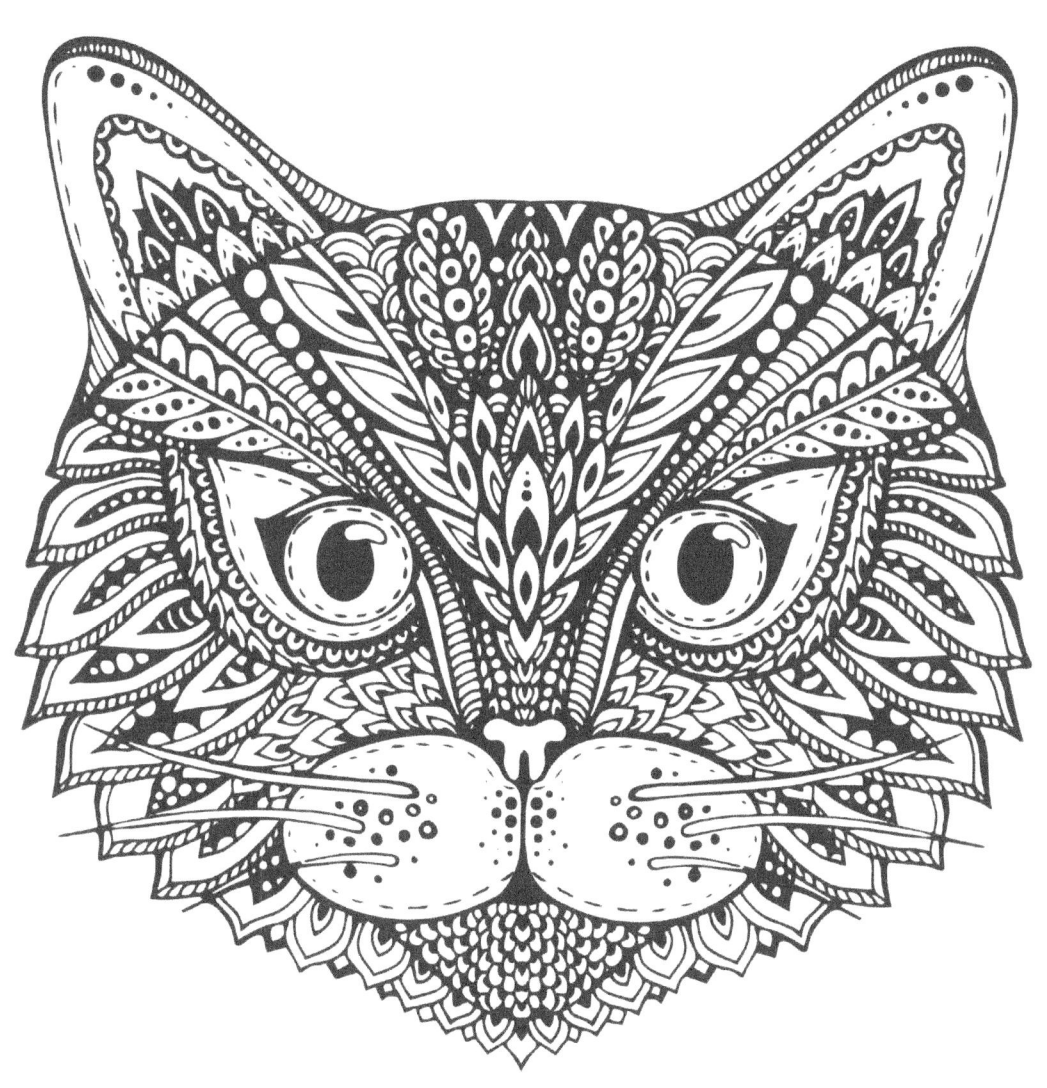

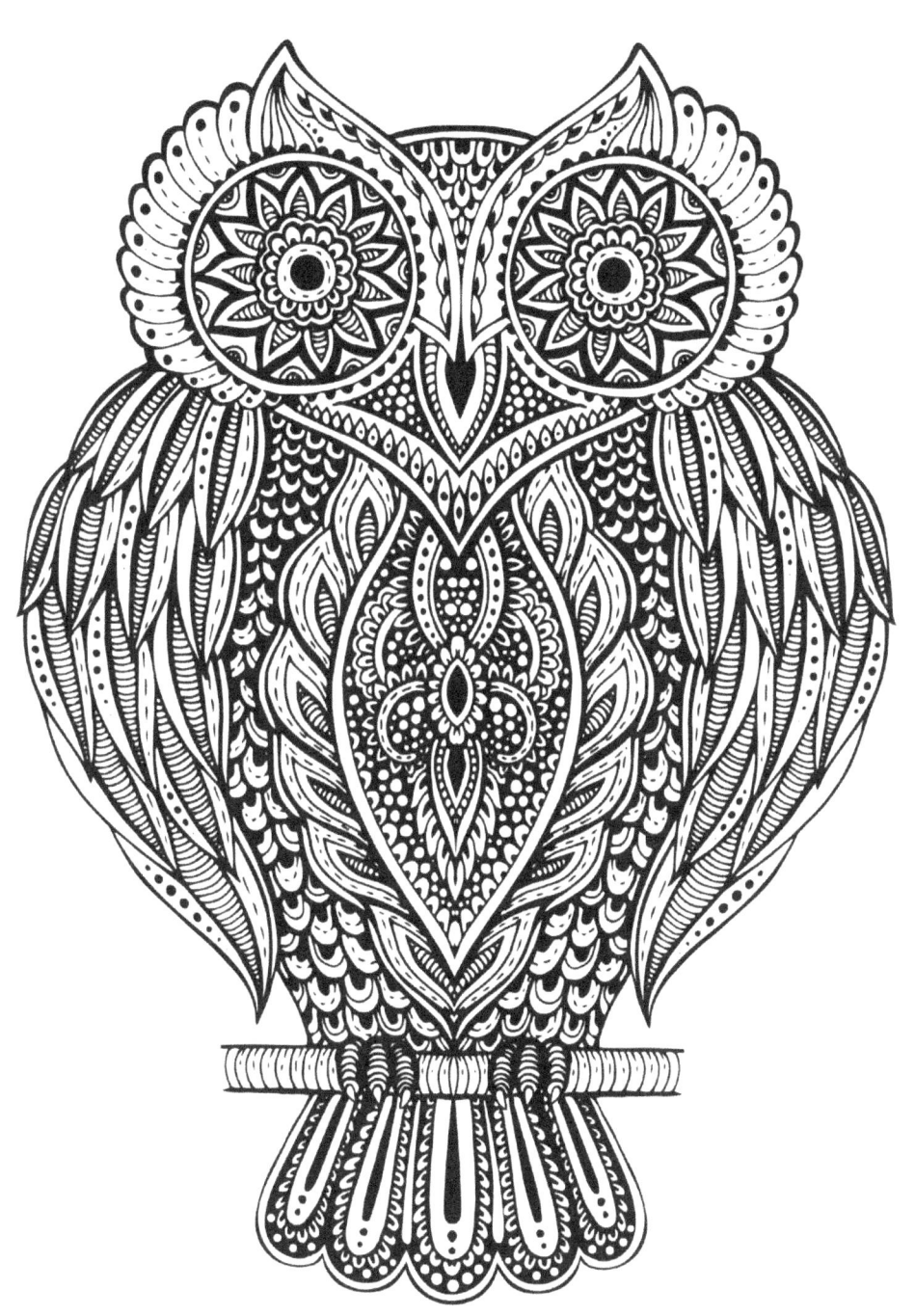

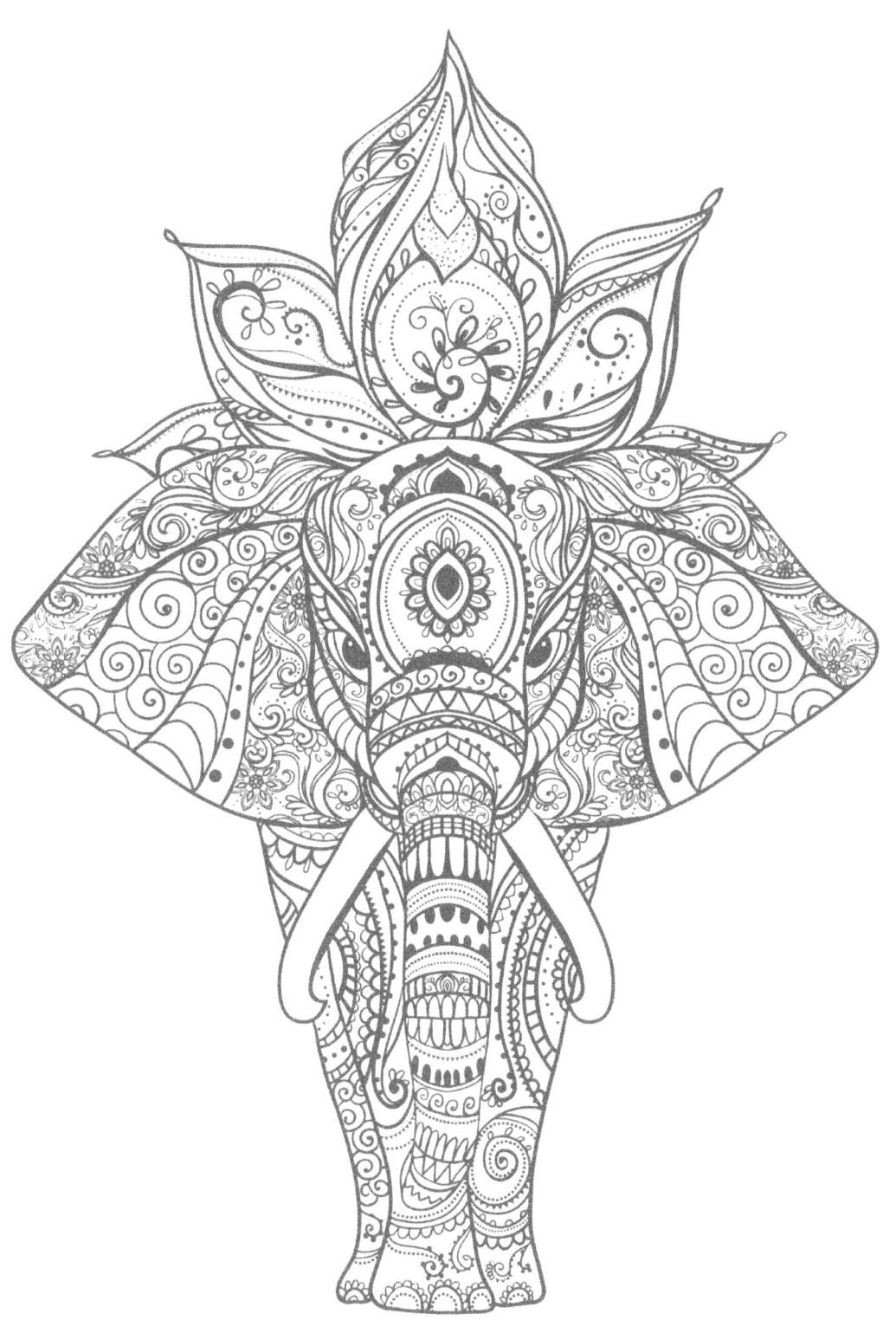

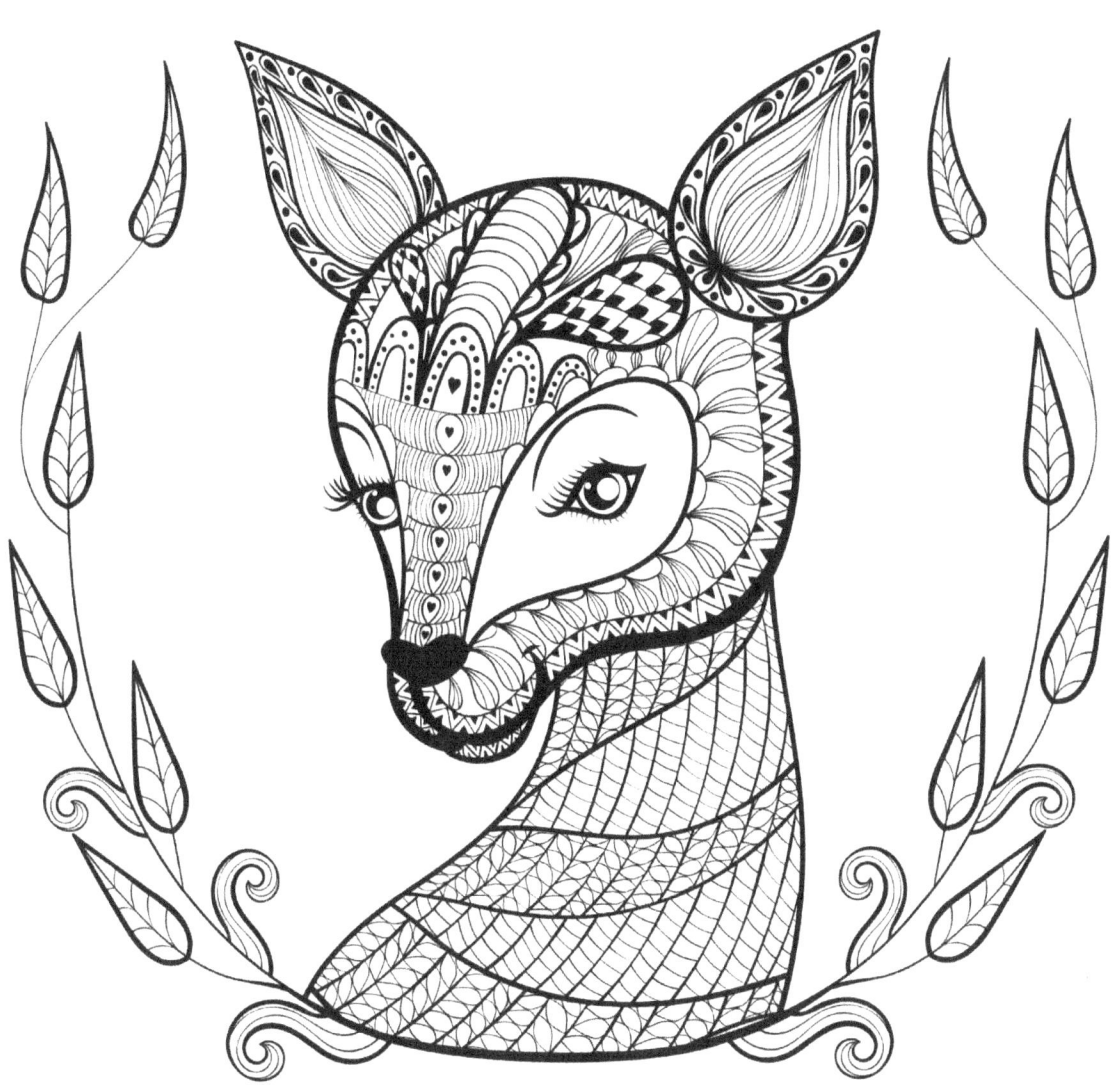

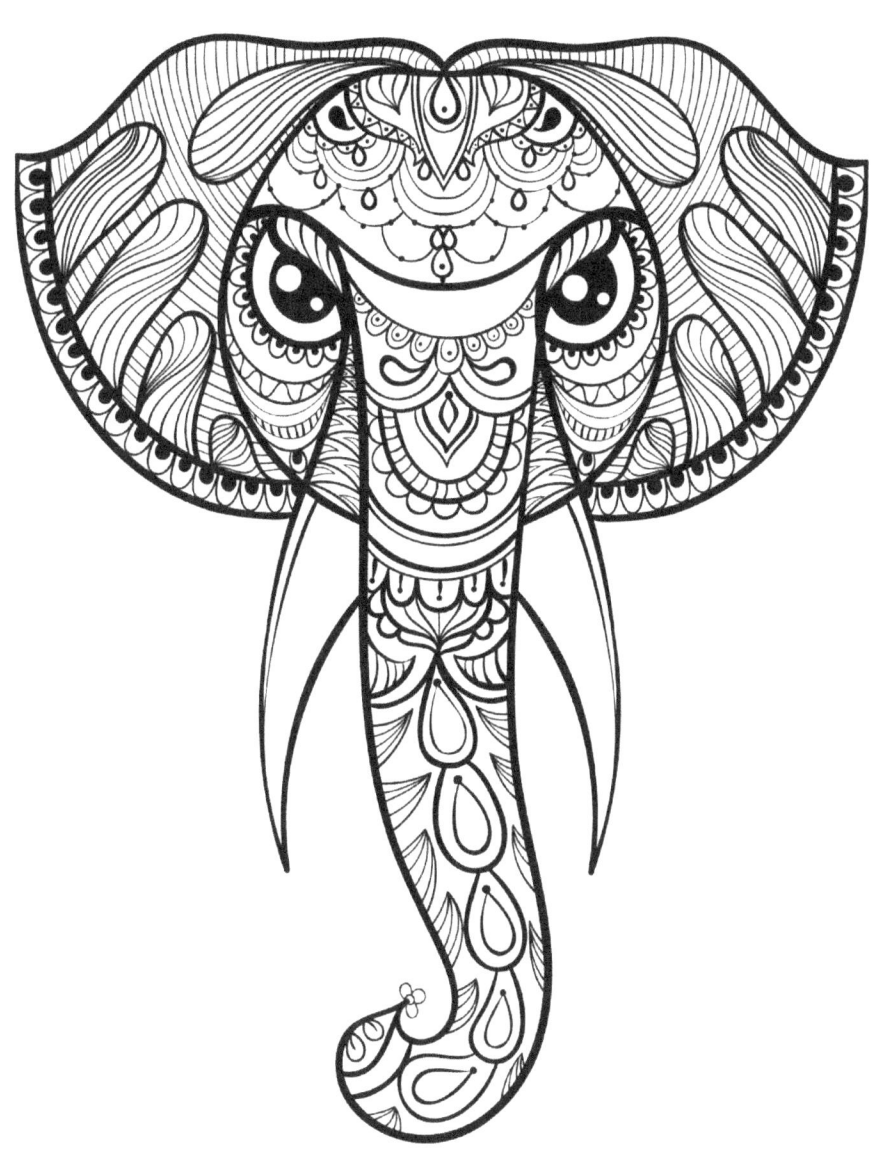

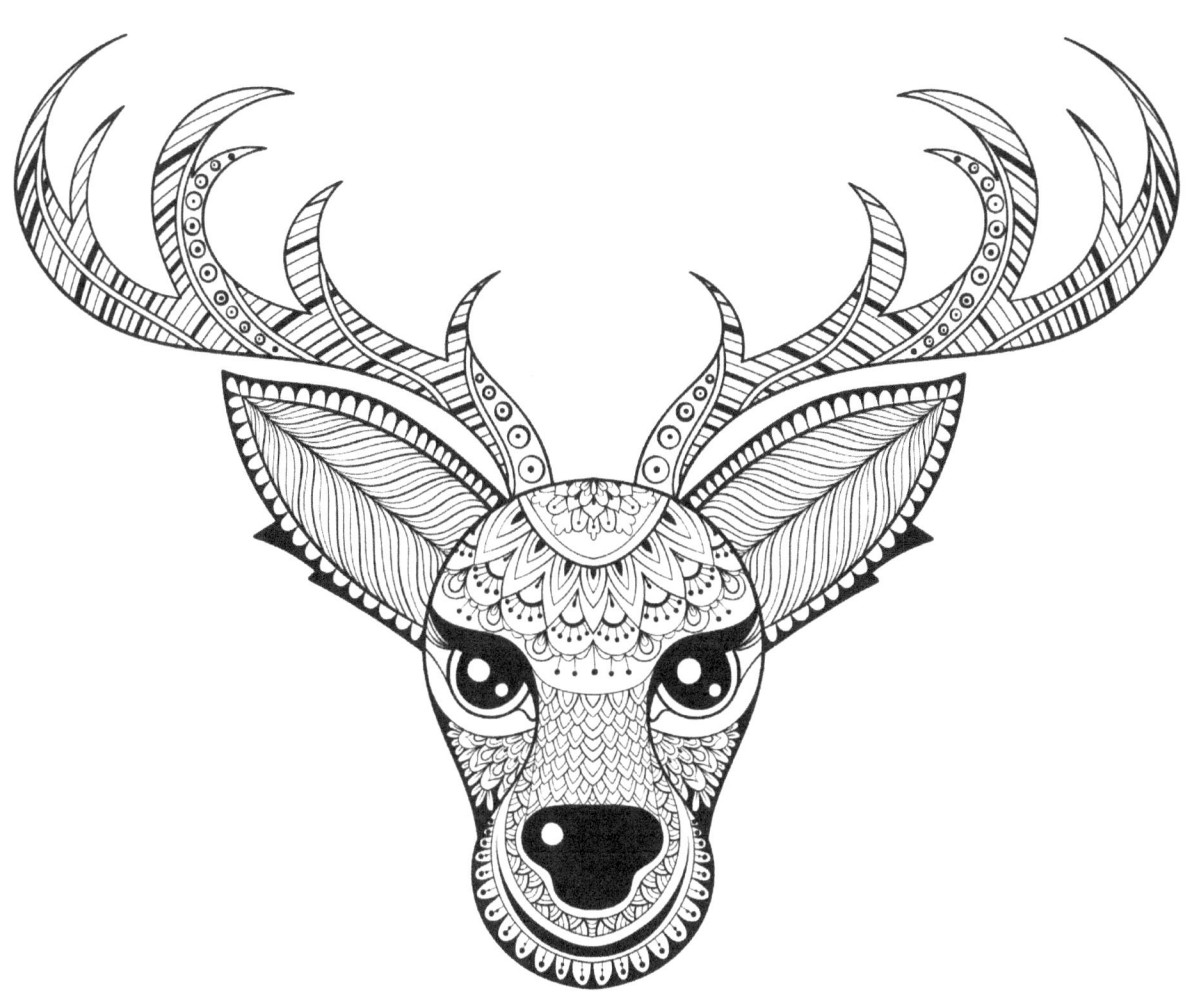

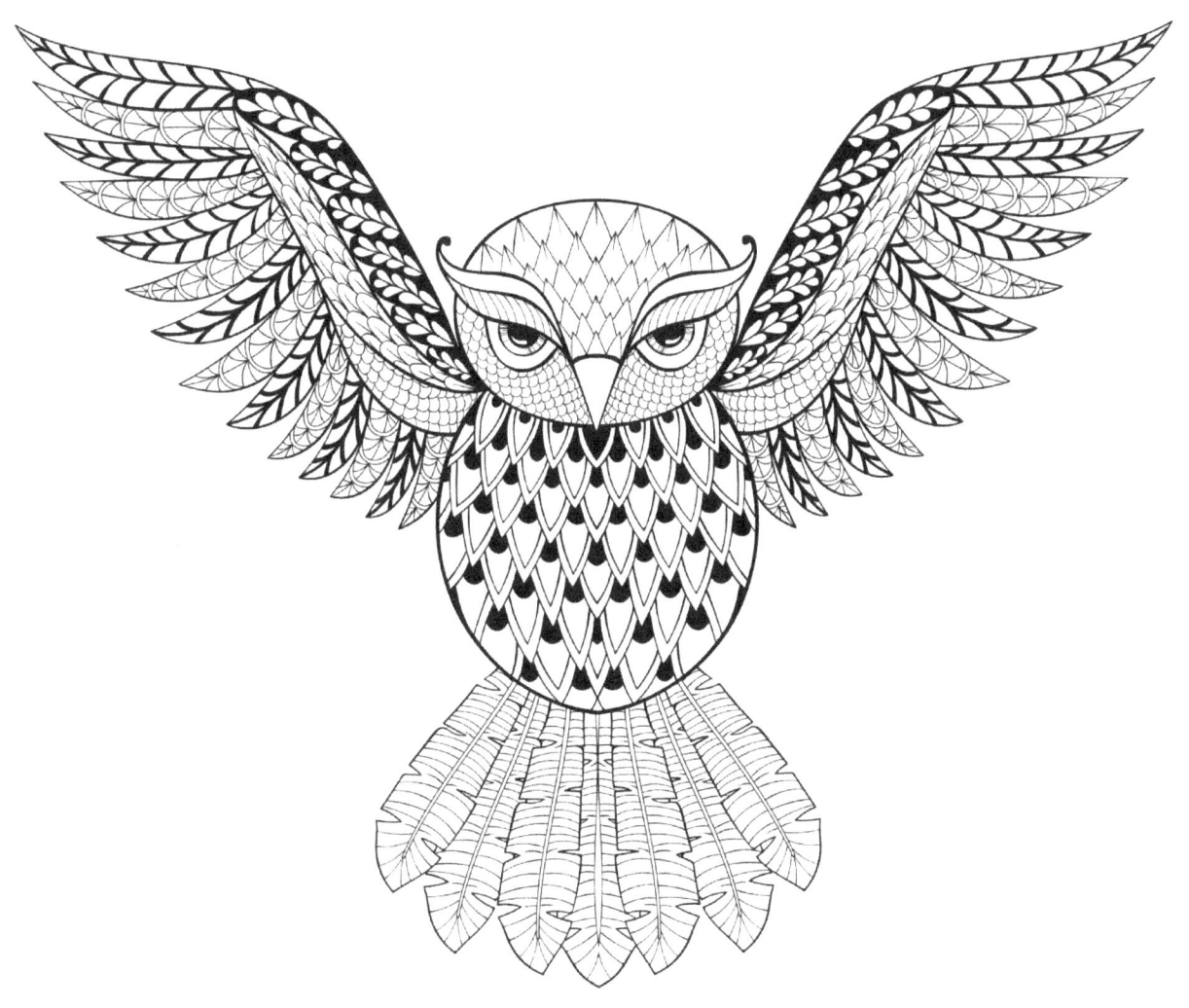

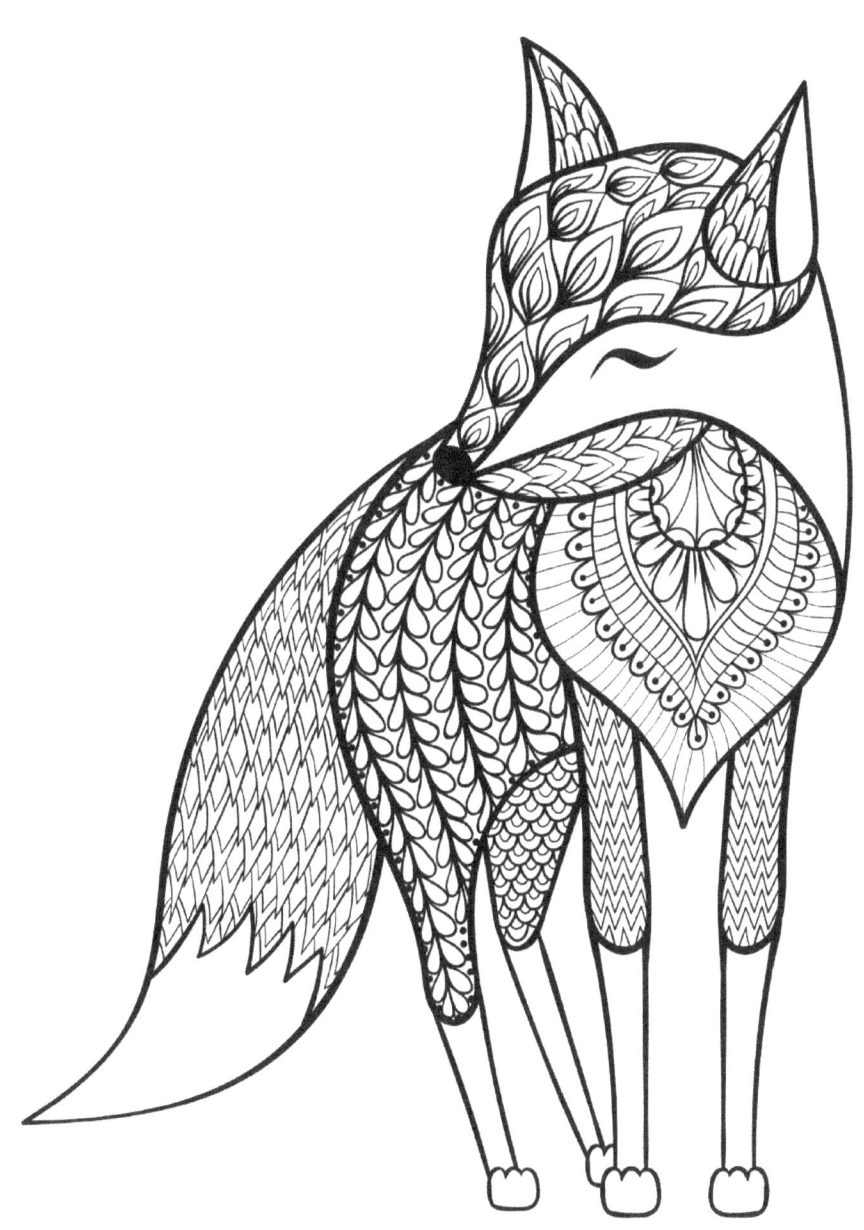

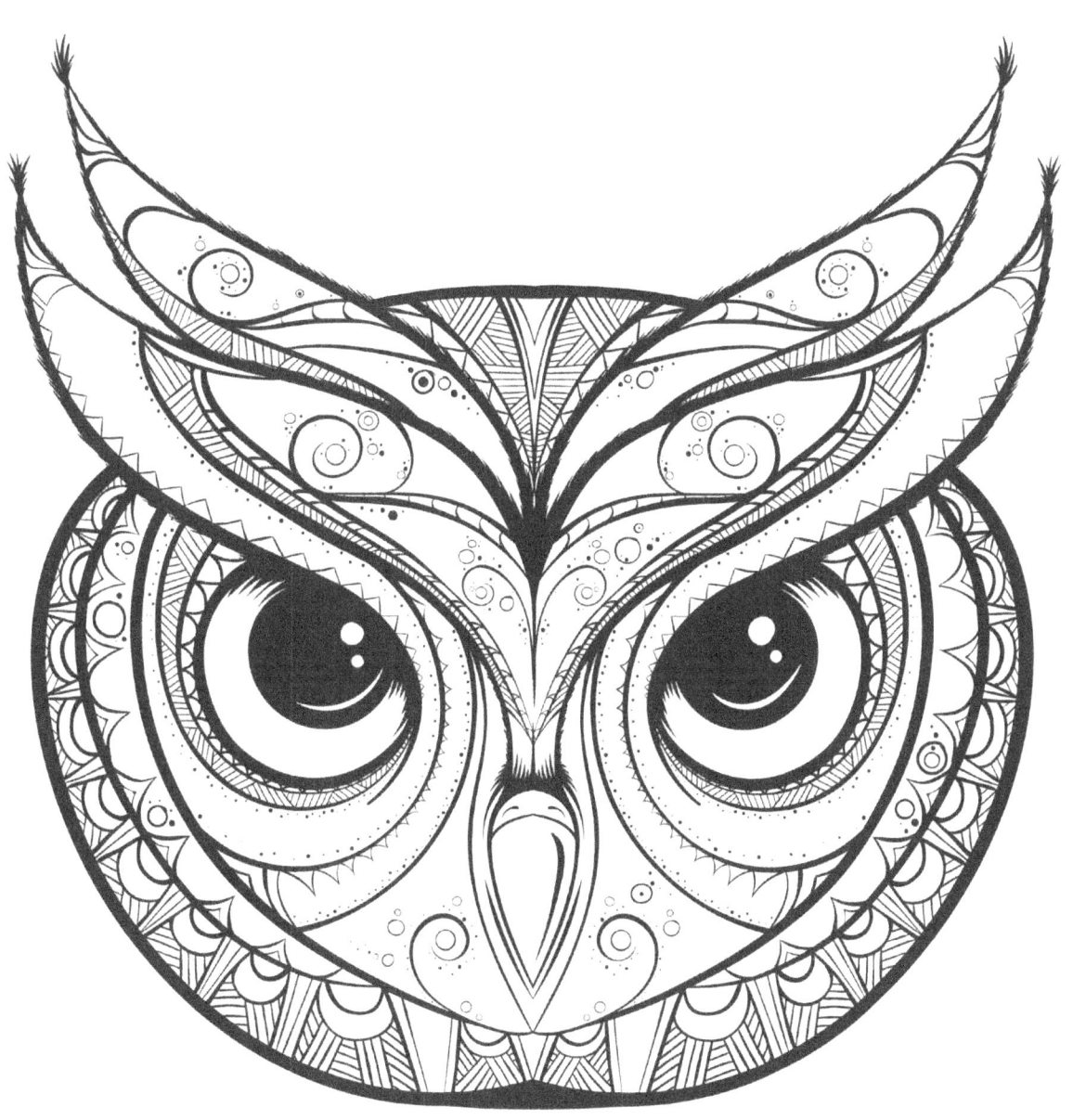

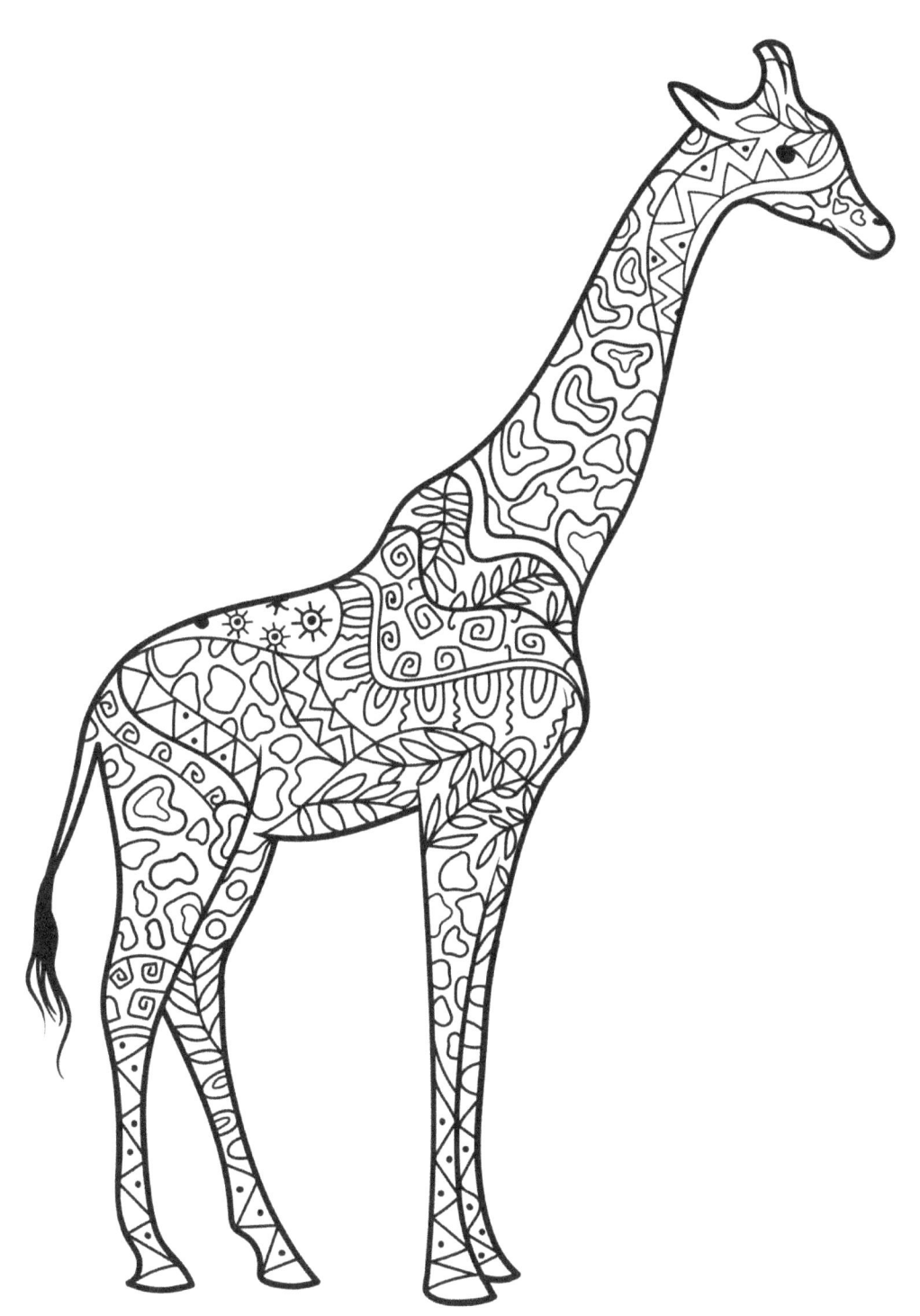

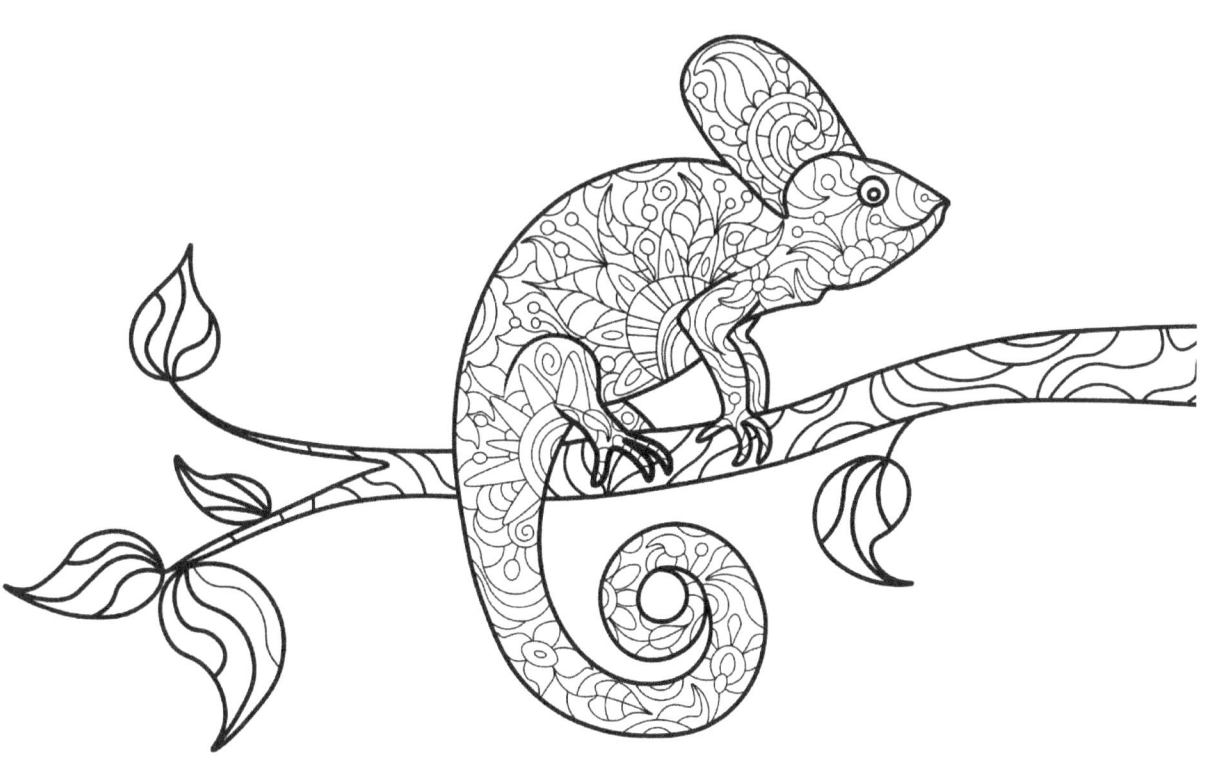

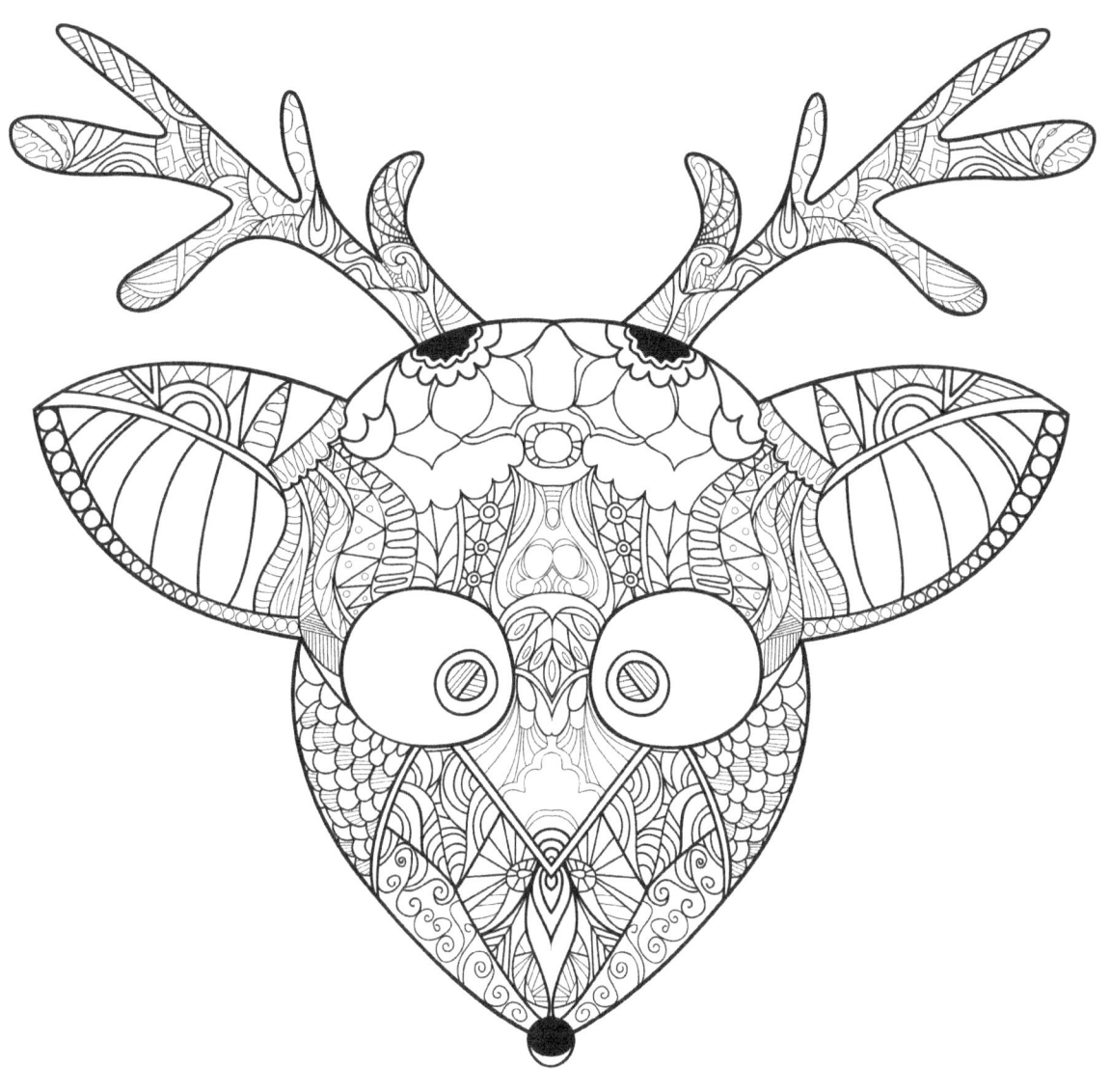

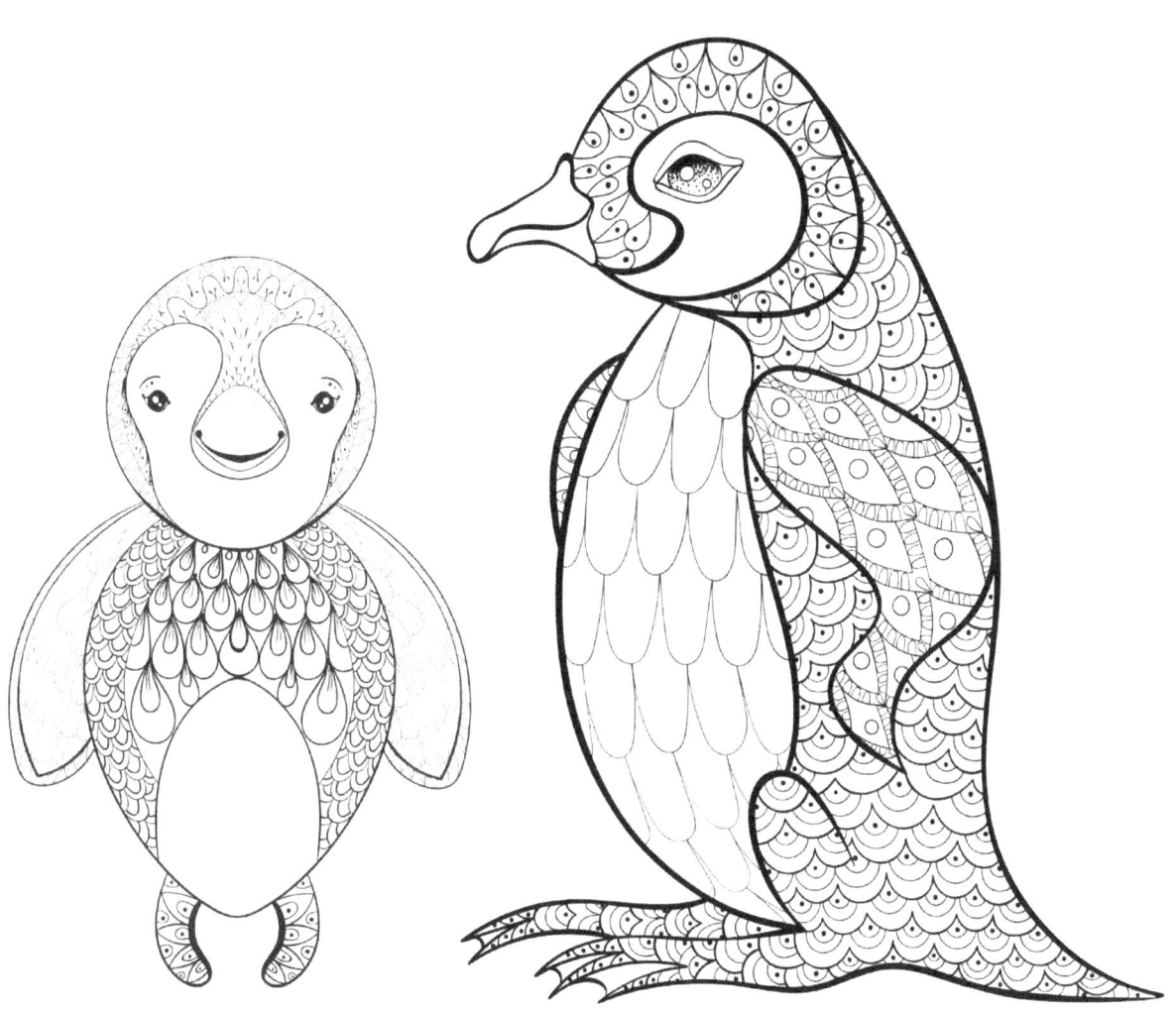

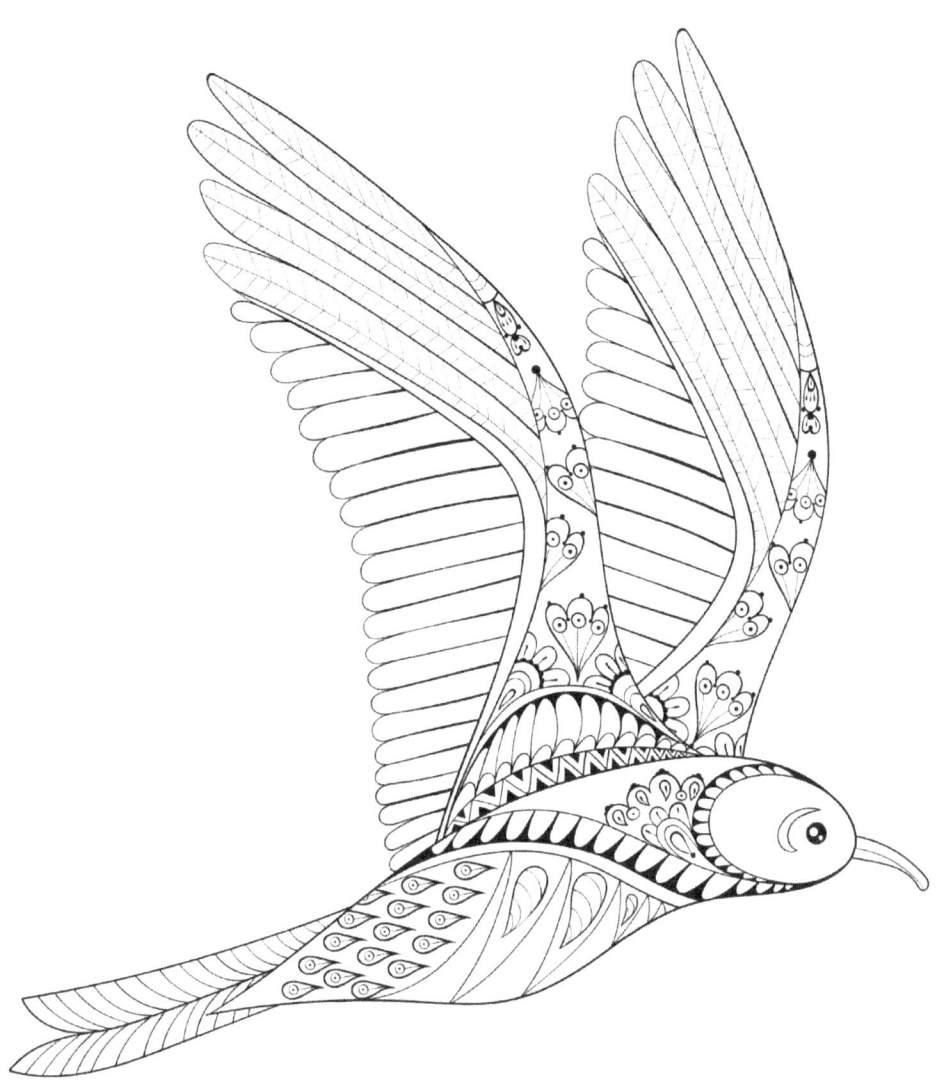

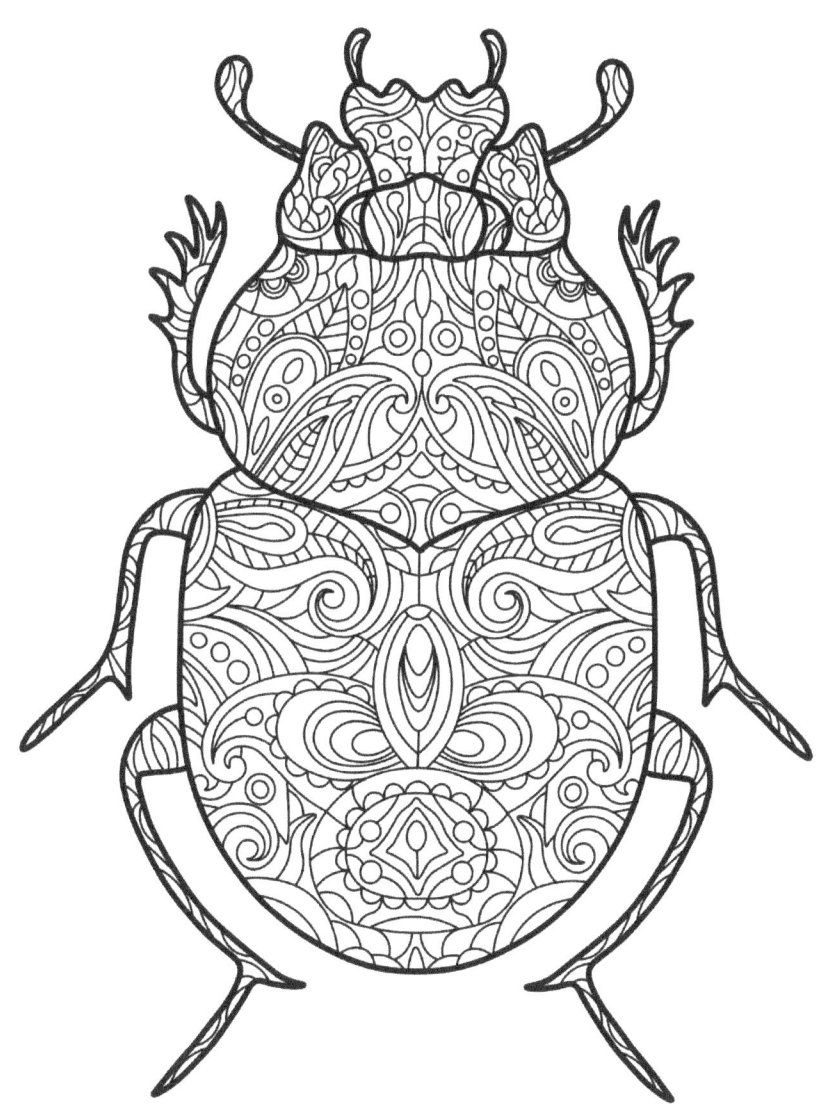

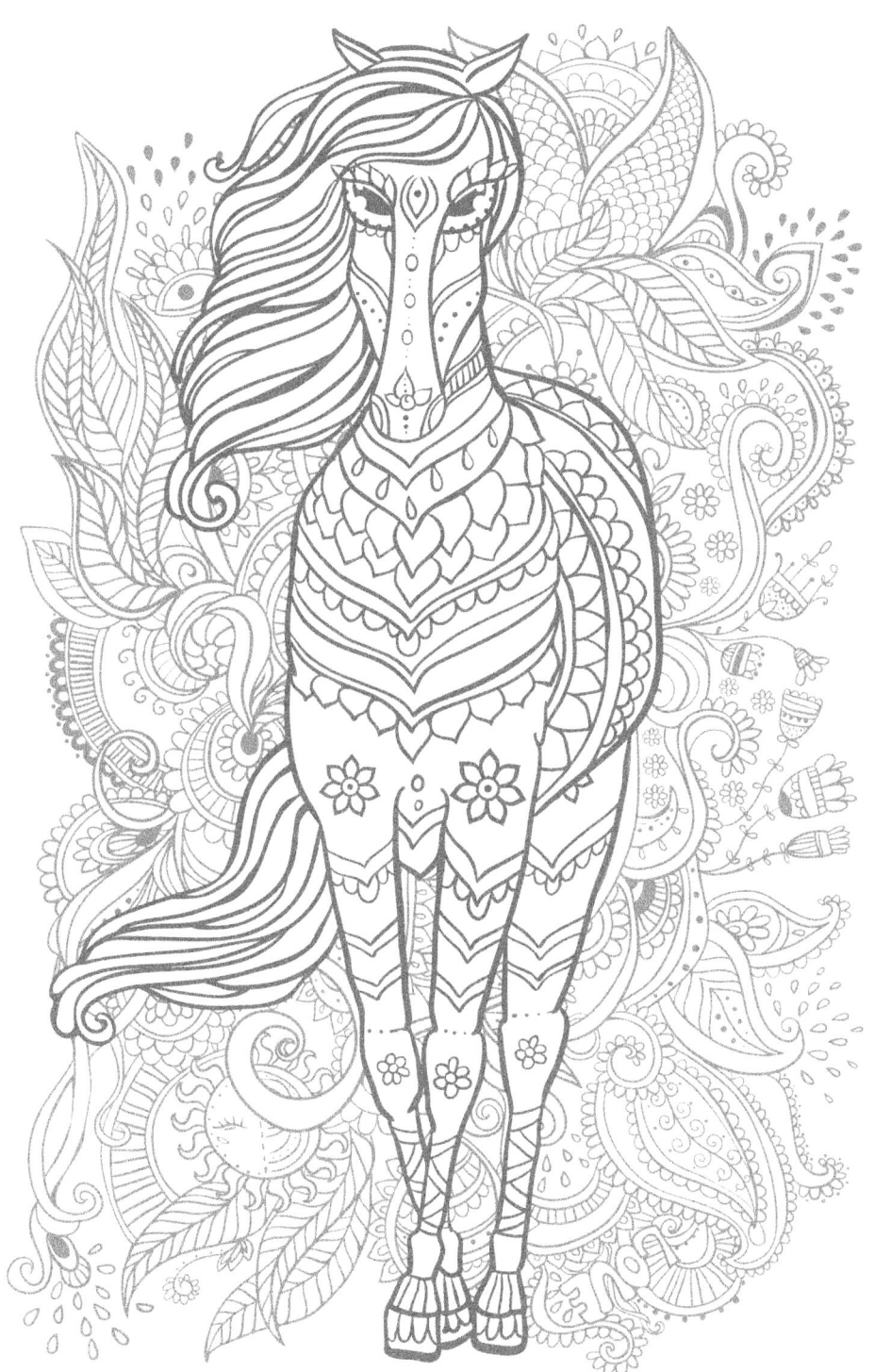

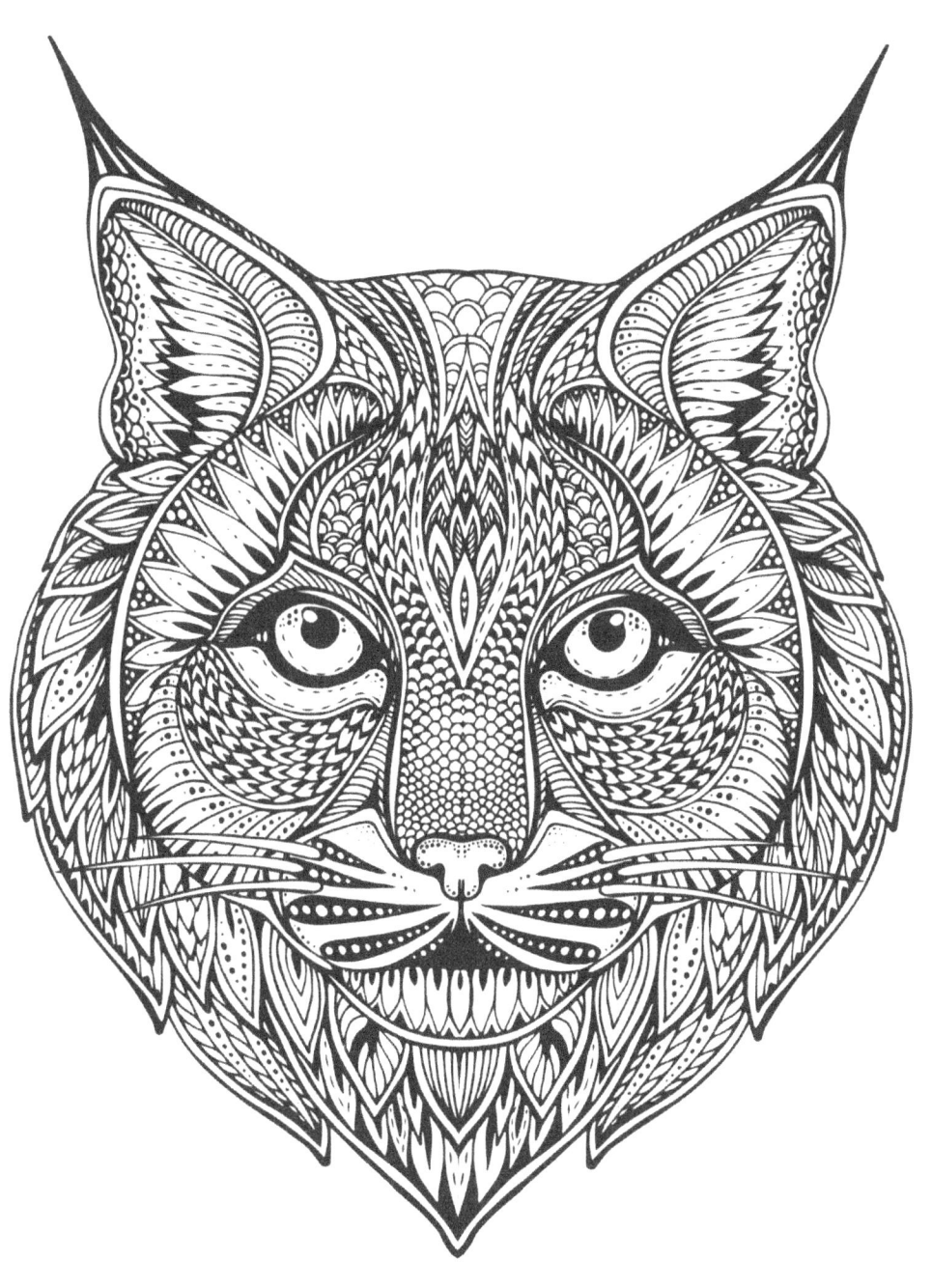

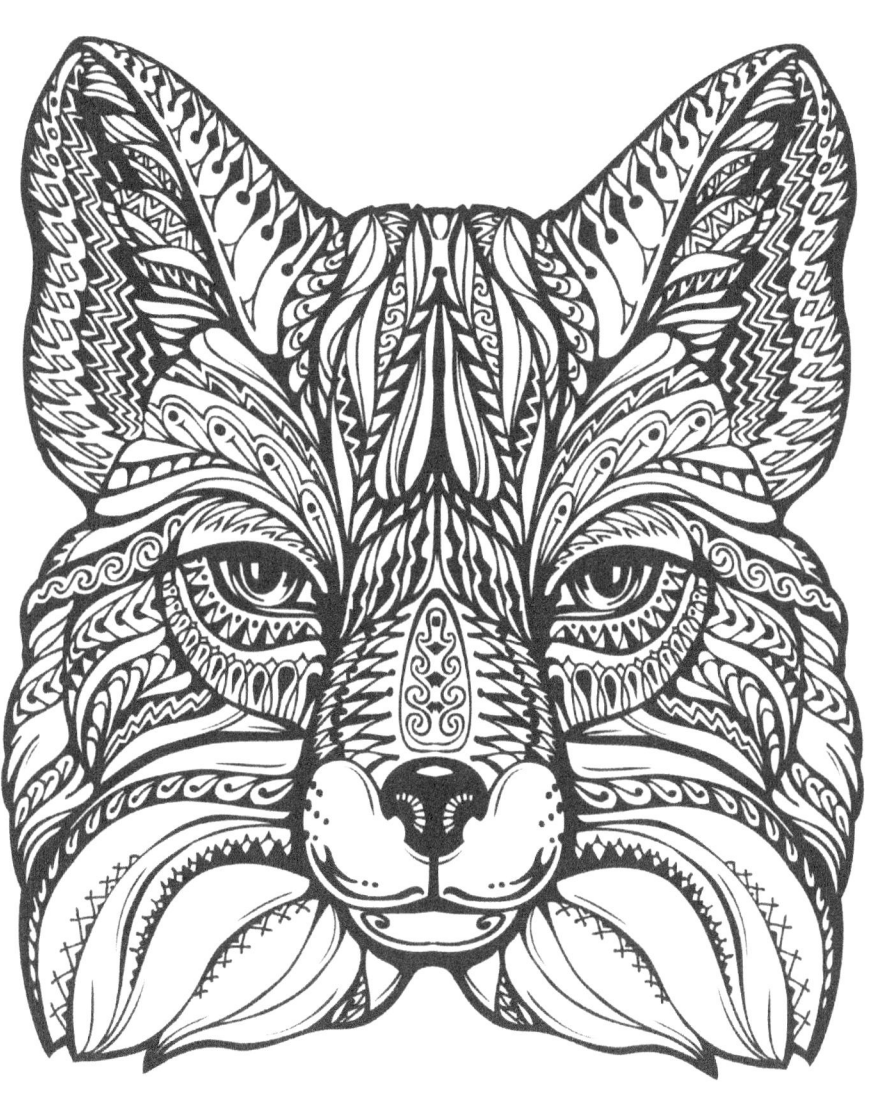

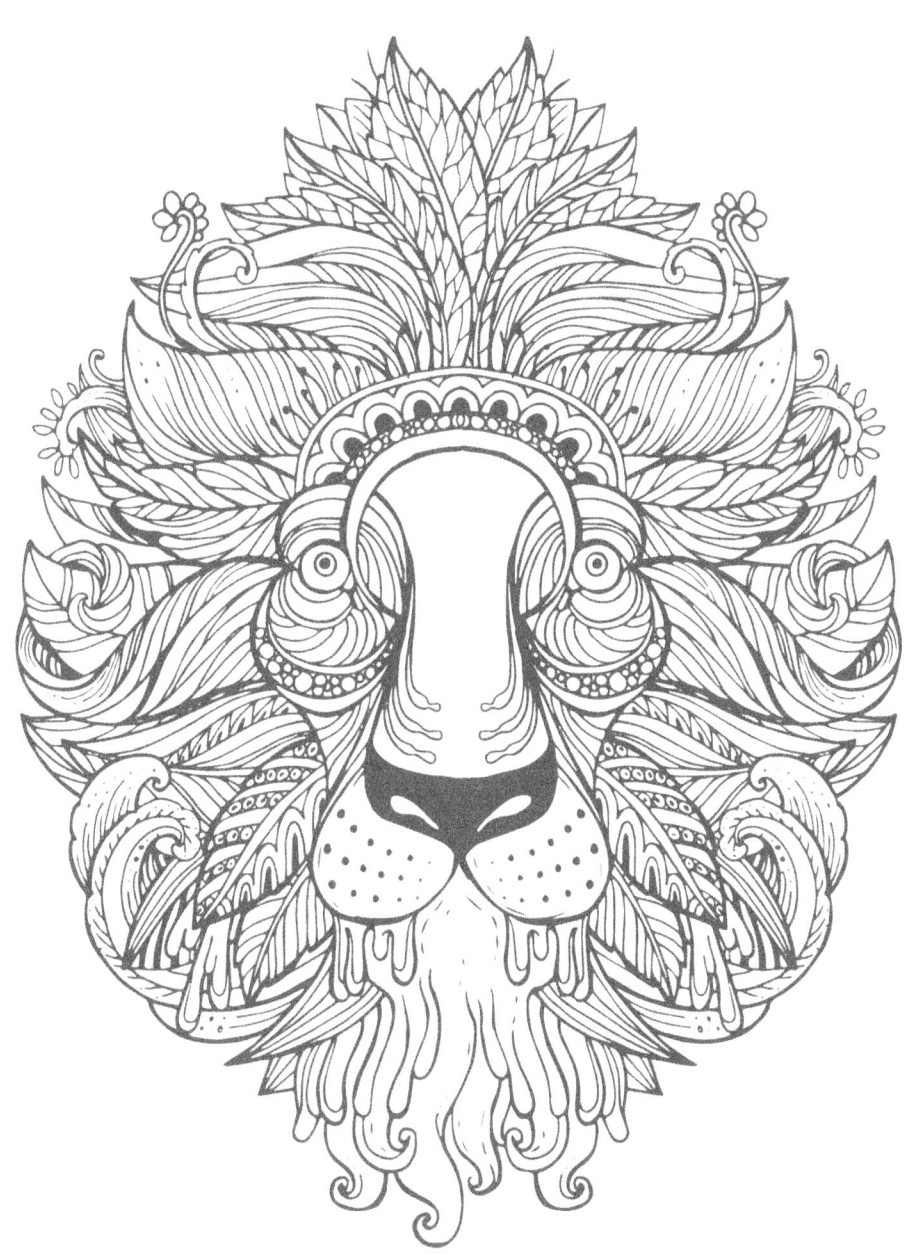

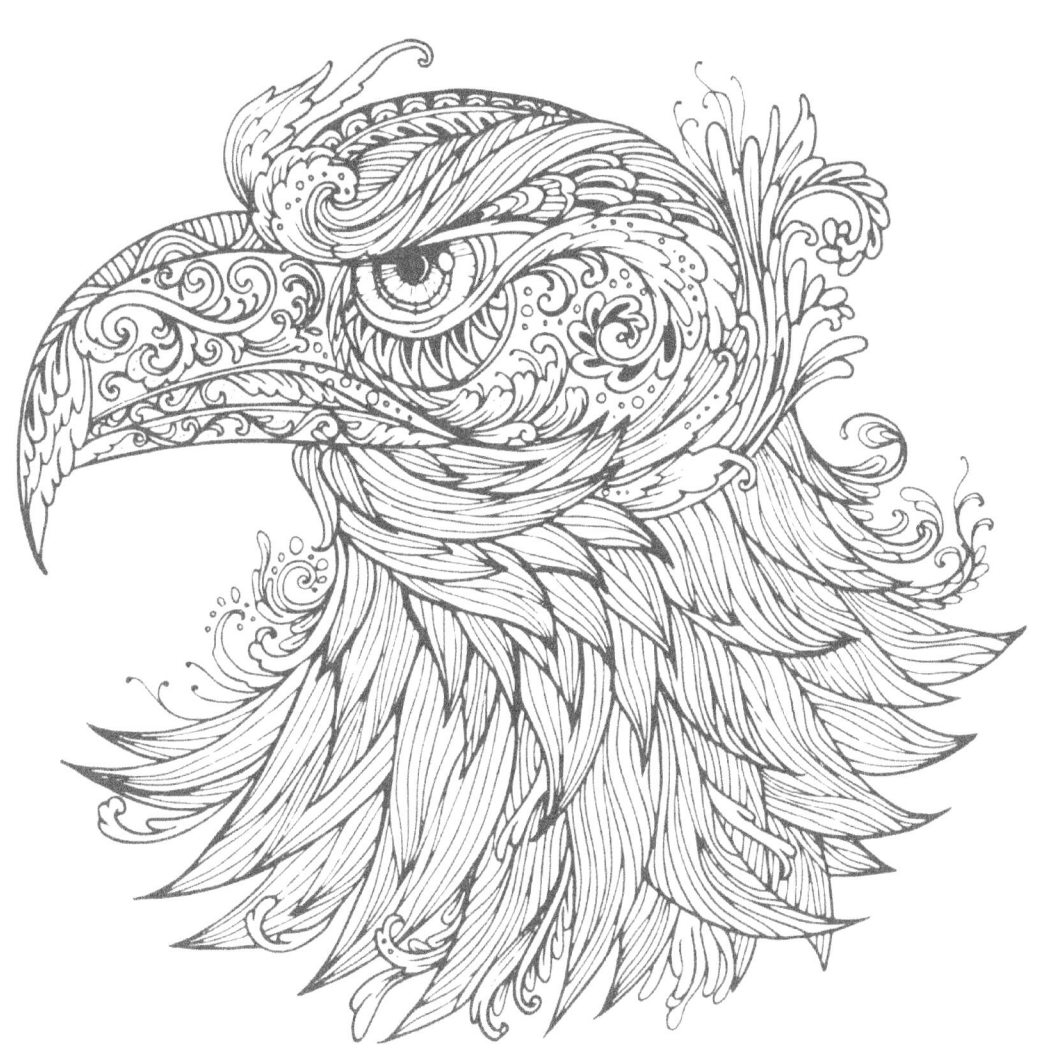

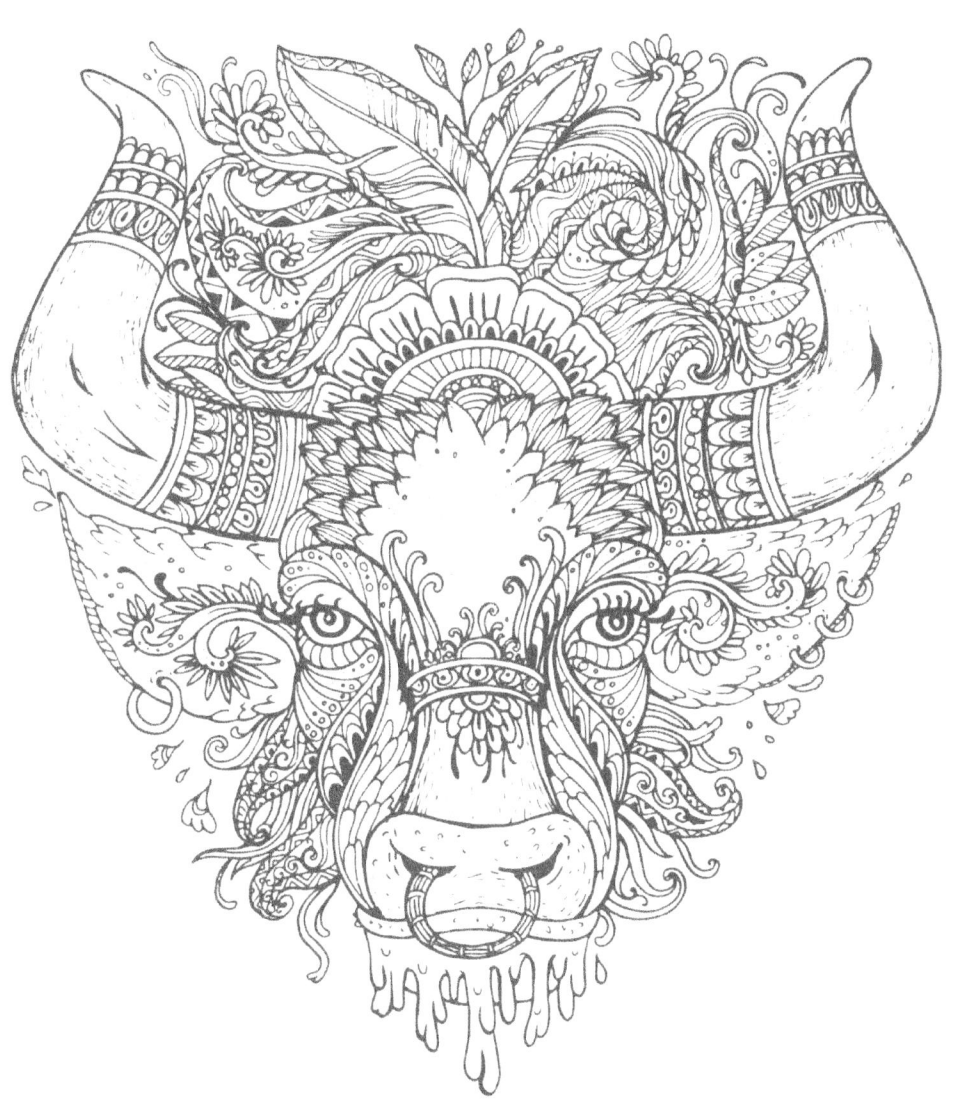

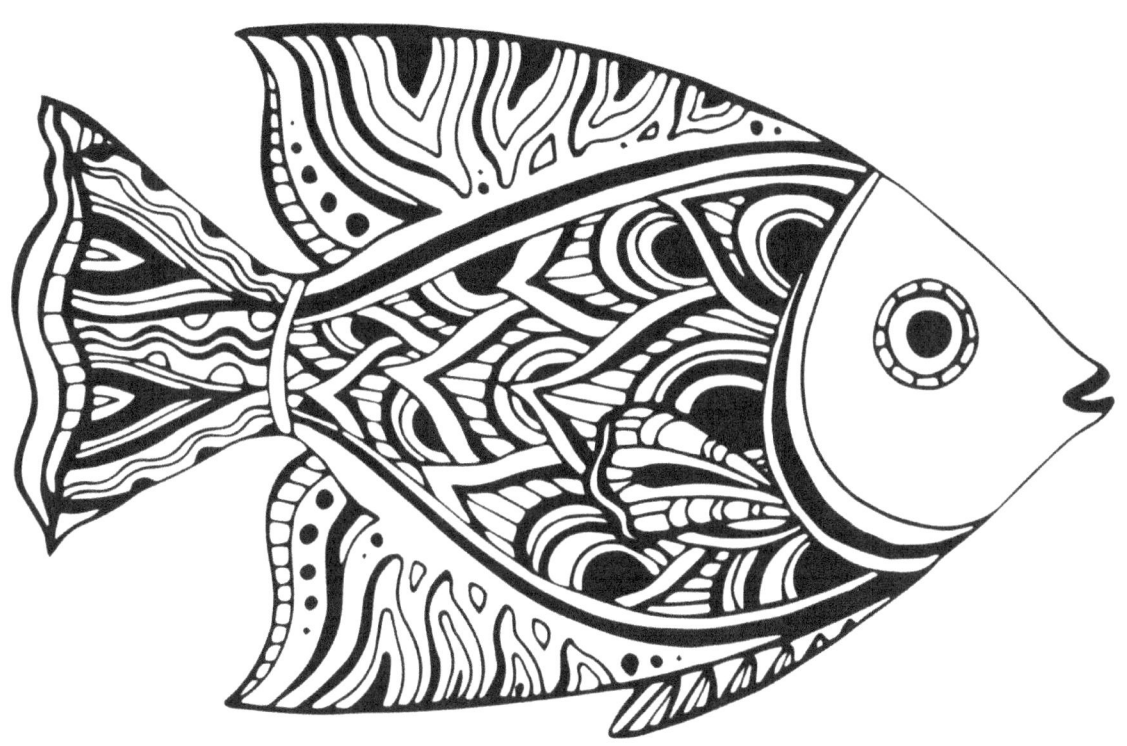

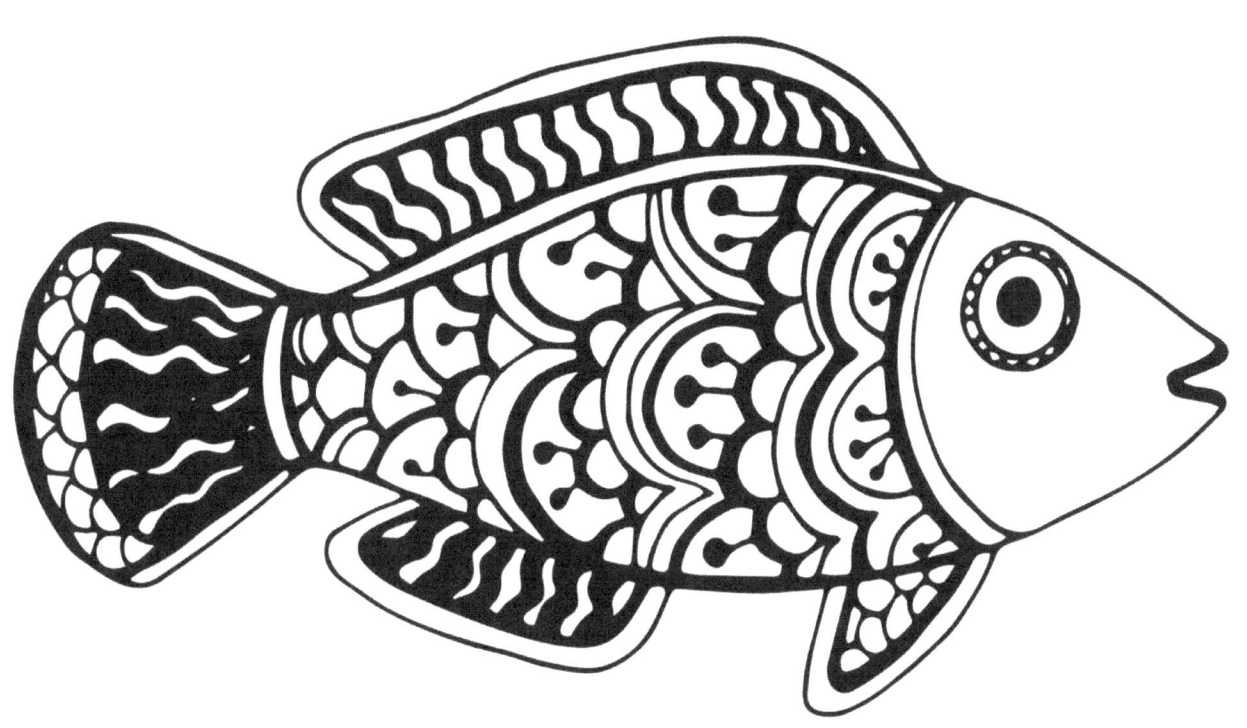

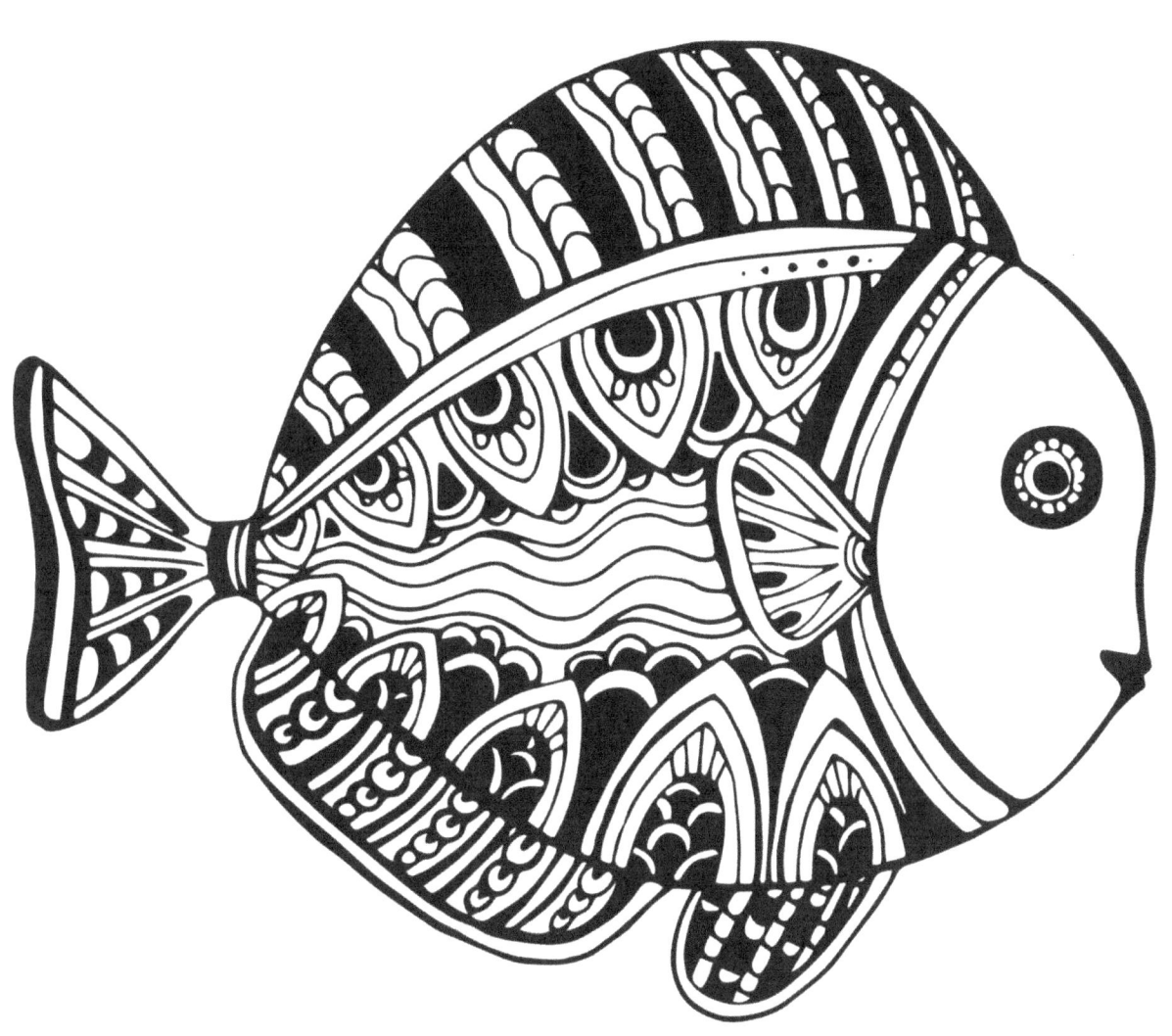

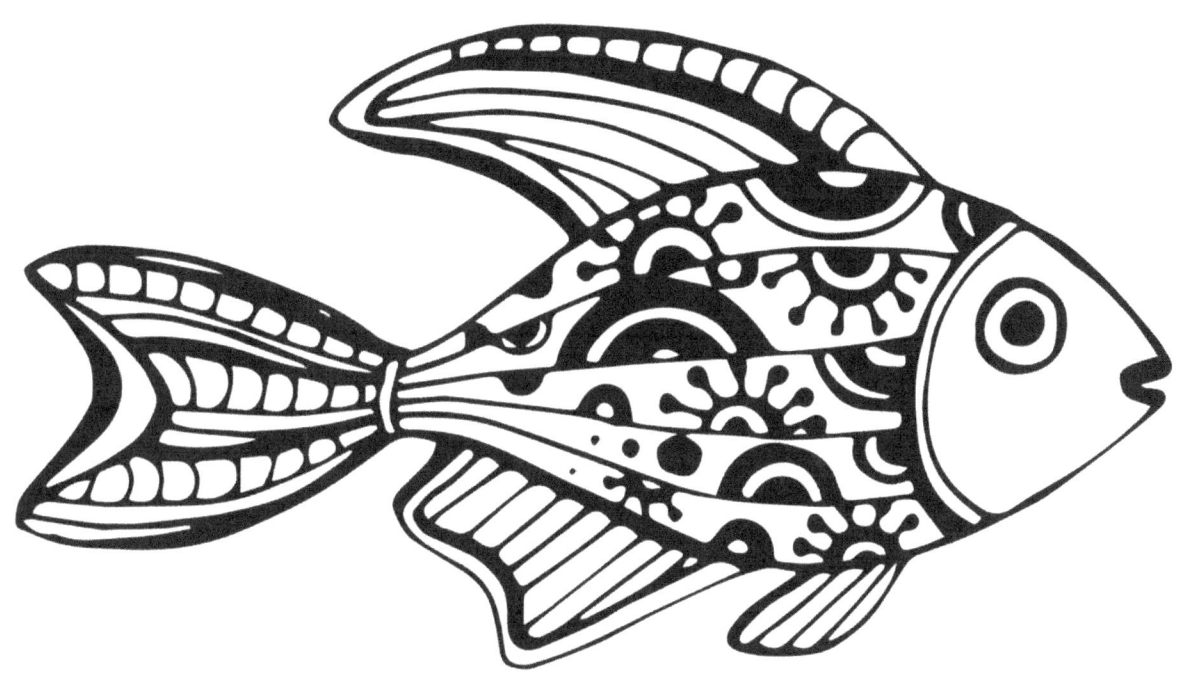

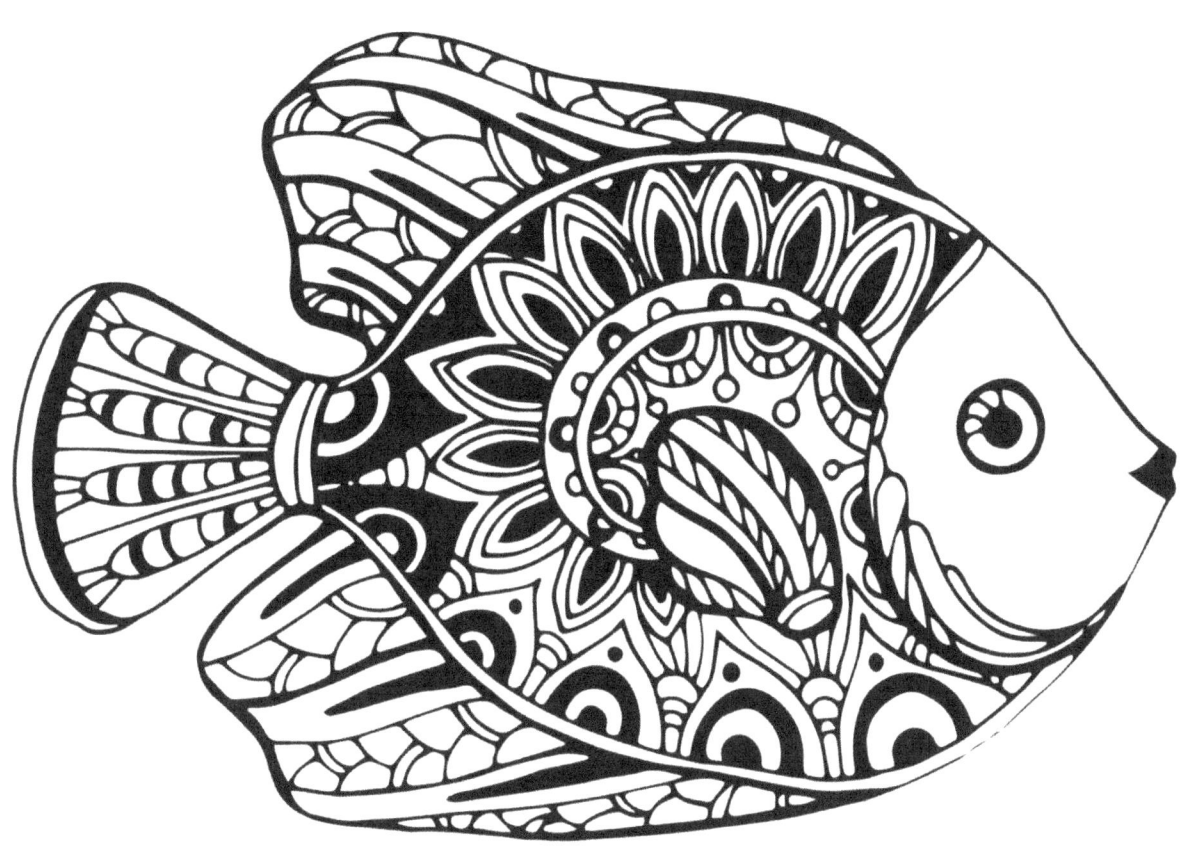

PDF Version this book : http://bit.ly/cat_c_1

Don't Miss Another our Books.

http://bit.ly/safari_coloring_b

ISBN : 9781523987931
(Use this ISBN for searching on amazon.com)

Join Us >> http://bit.ly/get_sample_free
When we release new book, we will send you the free sample first.
Thank you.

www.ingramcontent.com/pod-product-compliance
Lightning Source LLC
Chambersburg PA
CBHW081122180526
45170CB00008B/2970